More Than Just An Artnership

By
Heather K. Eddy Artwork
Brian K. Eddy Poems

©2017

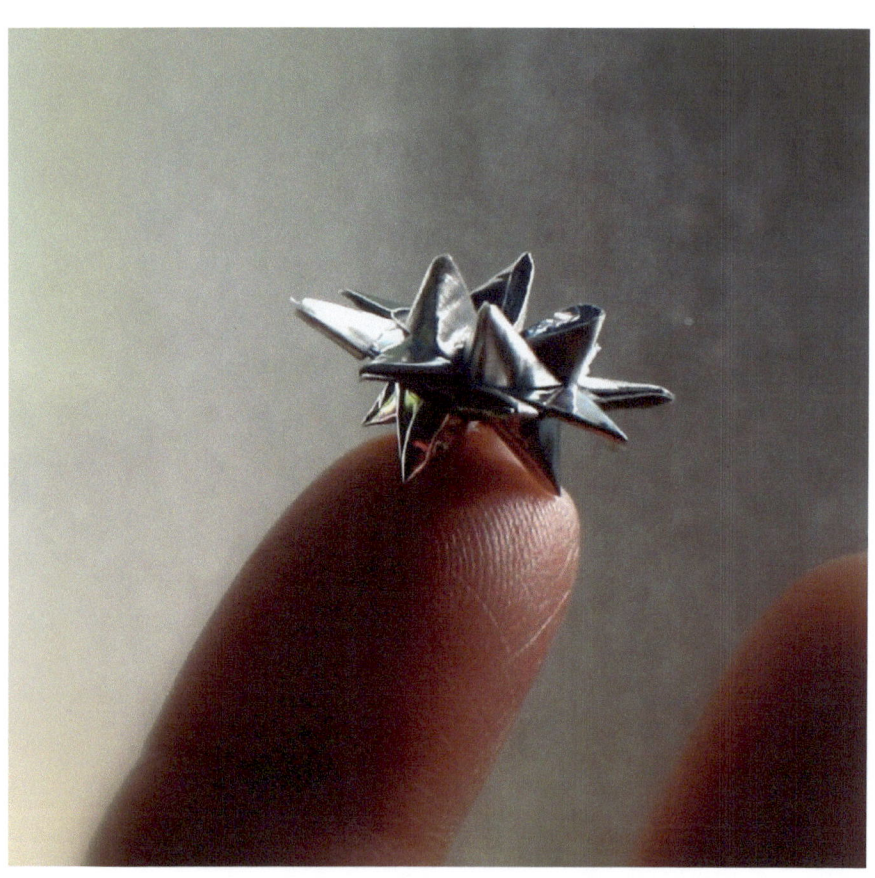

A Baby Star

The smallest star you've ever seen,
Isn't yellow, red or green,
Of purest silver it does shine,
A baby star, yet divine.

While she may not be a big thing,
Before too long she will bring,
A gentle beauty to the skies,
Sharing light with mortal eyes.

Once she's joined that celestial fold,
Hear the future now foretold,
Of countless wishes made on her,
The purest, of love, endure.

10/14/15

Commentary p.56

Introduction

Art is an expression of one's soul. What medium you use, be it oils, sculpture, watercolors or poetry, is quite unimportant. The creation of art opens a portal to the innermost feelings of the Creator.

What bravery therefore, is shown before the world. "Look at me", they cry, "I hurt, I love, I hope". And they beg the audience to share in their emotions.

An Expanded Artnership is a continuation of the adventure begun in *A Creative Artnership*. Heather's beautiful art pieces paired to my own poetic flights.

In each case, the poem has been inspired by the artwork and as such owes its very existence to the physical piece.

We hope you will enjoy this feast for the eye and the heart.

Table of Contents

A Baby Star p2 (p)

Introduction p5

Table of Contents p6-7

Come Unto the Ark p8 (w)

She Sang the Song of Love p10 (b)

Paper Roses p12 (p)

The Little Red House: Something here Inside p14 (w)

Crevasse p16 (w)

Poppy p18 (c)

Relief Always Comes p20 (w)

Crazy In Love p22 (w)

Little Pink p24 (p)

The Little Red House: My Child p26 (w)

In Her Silence Was a Cry p28 (w)

A Woman, a Spaniel and a Walnut Tree p30 (w)

Read p32 (p)

The Little Red House: Settling In p34 (w)

Lovebrary p36 (c)

When the Time Comes p38 (w)

The Polka Dot Ball p40 (p)

Mortality's Fall p42 (w)

A Green Heart p44 (w)

Wheat Sheaves p46 (b)

The Little Red House: In Repose p48 (w)

When the Spikes Come Out p50 (p)

Rosemary p52 (w)

The Volcano p54 (w)

Commentary pp 56-80

About the Authors p81

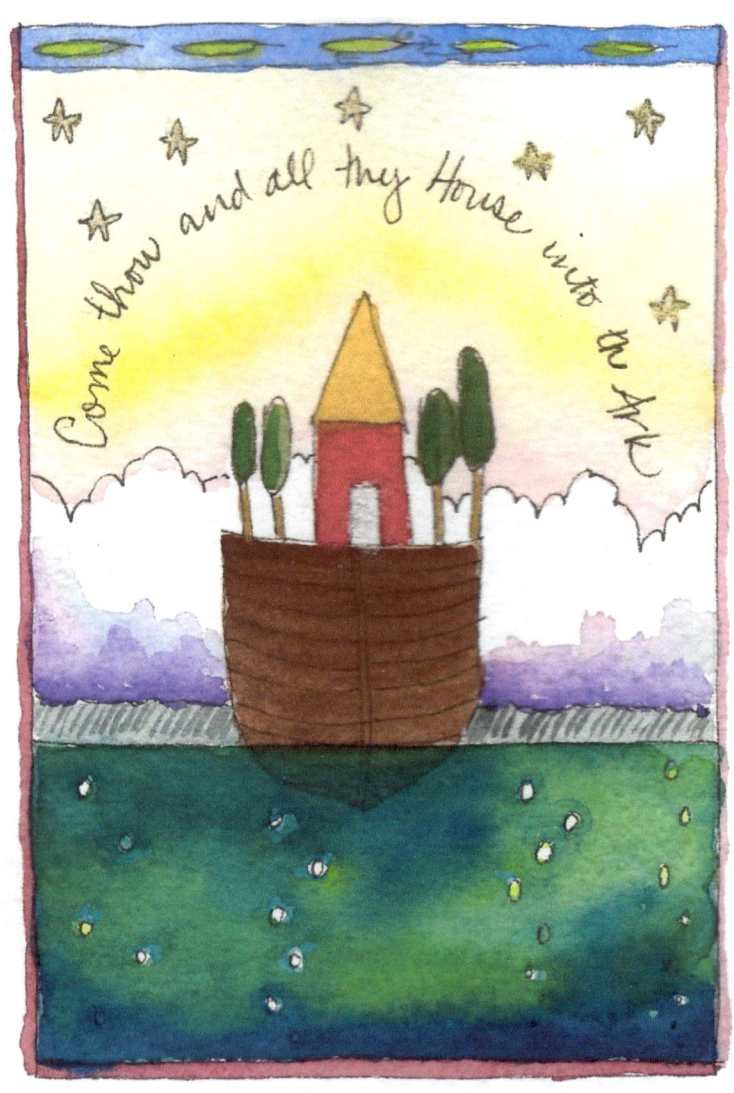

Come Into the Ark

Violent storms are gathering,
The skies are turning dark,
Listen to salvation's cry,
"Come into the ark!"

Gather all your little ones,
Say unto them, "Hark!
There is safety in His way,
"Come into the ark."

There's room enough for all who heed,
Soon we must embark,
Leave behind all worldly things,
"Come into the ark."

Our destination's eternity,
Receive the seal and mark,
Because we chose to humbly,
Come into the ark.

10/20/15

Commentary p.57

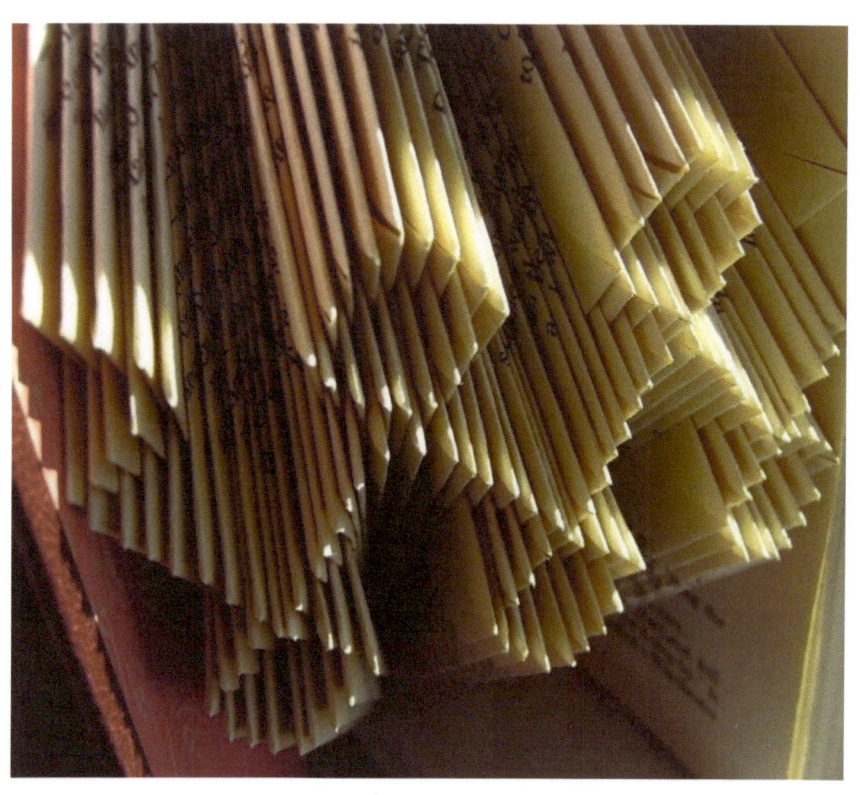

She Sang the Song of Love

Her face lit-up when ere we talked,
Consumed she was with joy,
And never was she more alive,
Then as her gifts employed.

A gentle heart, embraced the meek,
Encouraged those afraid,
Loving Grandma, devoted Mom,
Your happiness she craved.

I'd watch her as she led the hymn,
Voiced praises to our God,
Today for her the angels sang,
A welcome cheer and laud.

10/10/15

Commentary p.58

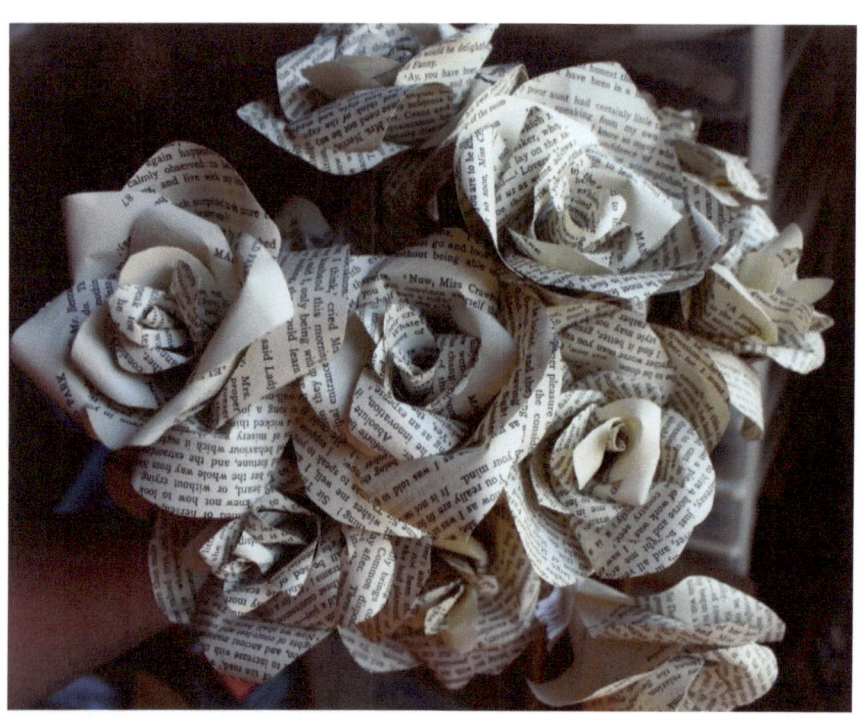

Paper Roses

She's folding paper roses,
Because flowers always die,
Their beauty fades to ashes,
Sweet perfume won't abide,

Within her paper roses,
Is found a bit of her,
That every soul who gets one,
Will know her love endures.

She says, "My paper roses,
May not be like the real ones,
Just as this life, with all its joys,
Is but a shadow of what's to come.

10/20/15

Commentary p.59

The Little Red House: Something Here Inside

I always thought that once he came,
My happiness would bloom,
That his touch upon my face,
Would chase away the gloom.

But something here inside aches,
Something here inside shakes,
Something here inside breaks,
Because it's not enough.

Sometimes, in the dead of night,
I wonder if I made,
The same stupid choice that,
Other women made.

Because something here inside aches,
Something here inside shakes,
Something here inside breaks,
What would be enough?

Other women tell me,
It's not so big a deal,
But they've all got their little ones,
I've just the emptiness I feel.

And something here inside aches,
Something here inside shakes,
Something here inside breaks,
When is my suffering enough?

10/21/15

Commentary p.60

Crevasse

Sometimes my life feels like,
I'm in a deep crevasse,
Sheer walls rising to the sky,
I've no choice of where to pass.

The view behind I've already seen,
Since I've just now come that way,
The view ahead doesn't show,
Which direction safety lay.

So I keep on walking,
Hoping for a sign,
That will show me a good life,
How to change the course of mine.

Maybe it's time to take control,
Become the master of my fate,
Climb out of this canyon drear,
Enjoy a fresh breeze upon my face.

10/21/15

Commentary p.61

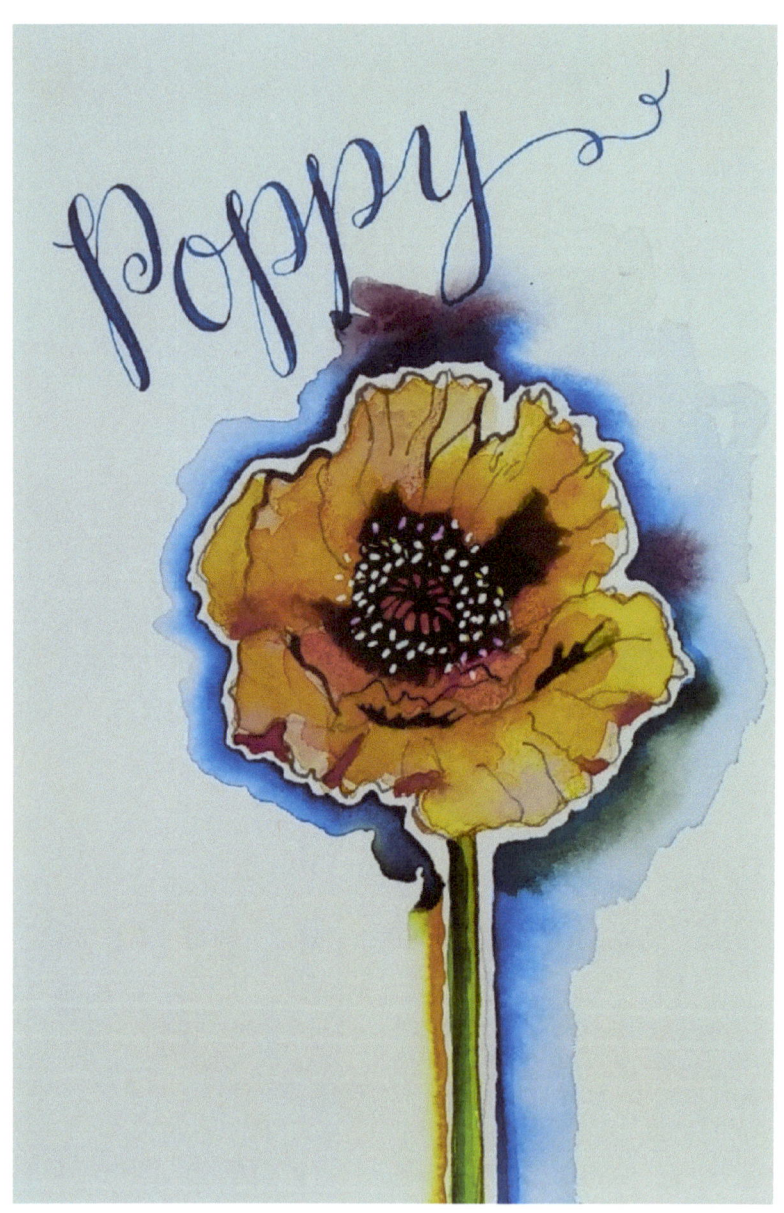

Poppy

I walked through the Flemish fields,
Heard ghosts cry out from the grave,
A million young men cut down,
Their nation's honor to save.

The flower of manhood died,
A generation now lost,
Those who returned were broken,
Could we ever count the cost?

Fathers not home to teach them,
Their son's hearts seething with heat,
Ambitious men to lead them,
A war, destined to repeat.

Not red but yellow poppies,
To pray the nations can heal,
Never again can we bear,
The horror of Flander's Fields.

10/21/15

Commentary p.62

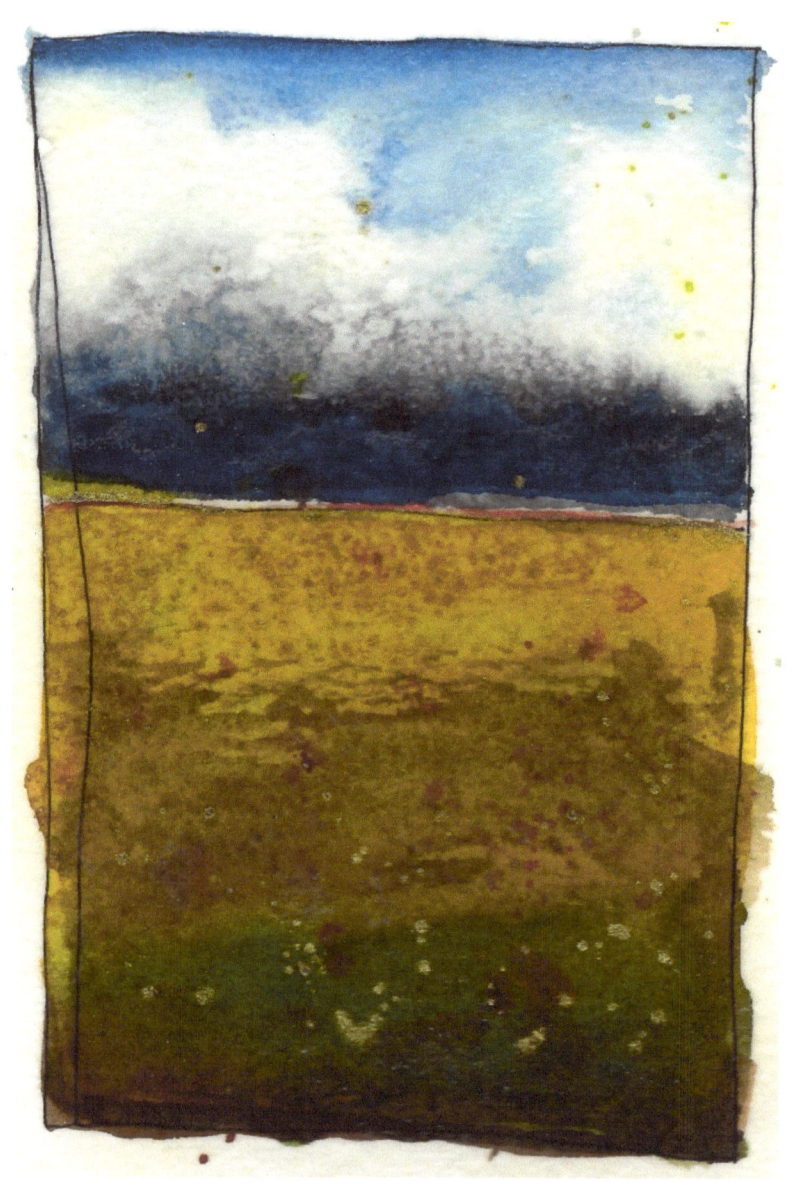

Relief Always Comes

Air lay thick and heavy upon the land,
Crushing the very breath from my lungs,
Dry brittle grass spread beneath shading hand,
Endless specks of dust to the currents hung.
I would have cried but tears were dry,
On the horizon lie, Hope I spied.

Dark and moist the vibrant clouds,
Promised relief from hellish heat,
Rolling o'er field and rook, tree parch-bowed,
Upturned faces, tiny raindrop blessings greet.
The cracked skin healed, streamlets rilled,
Break heaven's seal, when Man kneels.

9/27/15

Commentary p.63

WELL... what did you EXPECT?

Crazy in Love

I ran by in the nude,
Farted a tune,
Licking raccoons,
Well, what did you expect?

Lassoed me the bright moon,
Gave it to you,
Big rock…too soon?
Well, what did you expect?

Planned our wedding for June,
On a sand dune,
Best man's a baboon,
Well, what did you expect?

Two hours before noon,
Baby broke through,
In the bathroom,
Well, what did you expect?

Now we're three not two,
Don't have a clue,
What can you do?
Well, what did you expect?

10/18/15

Commentary p.64

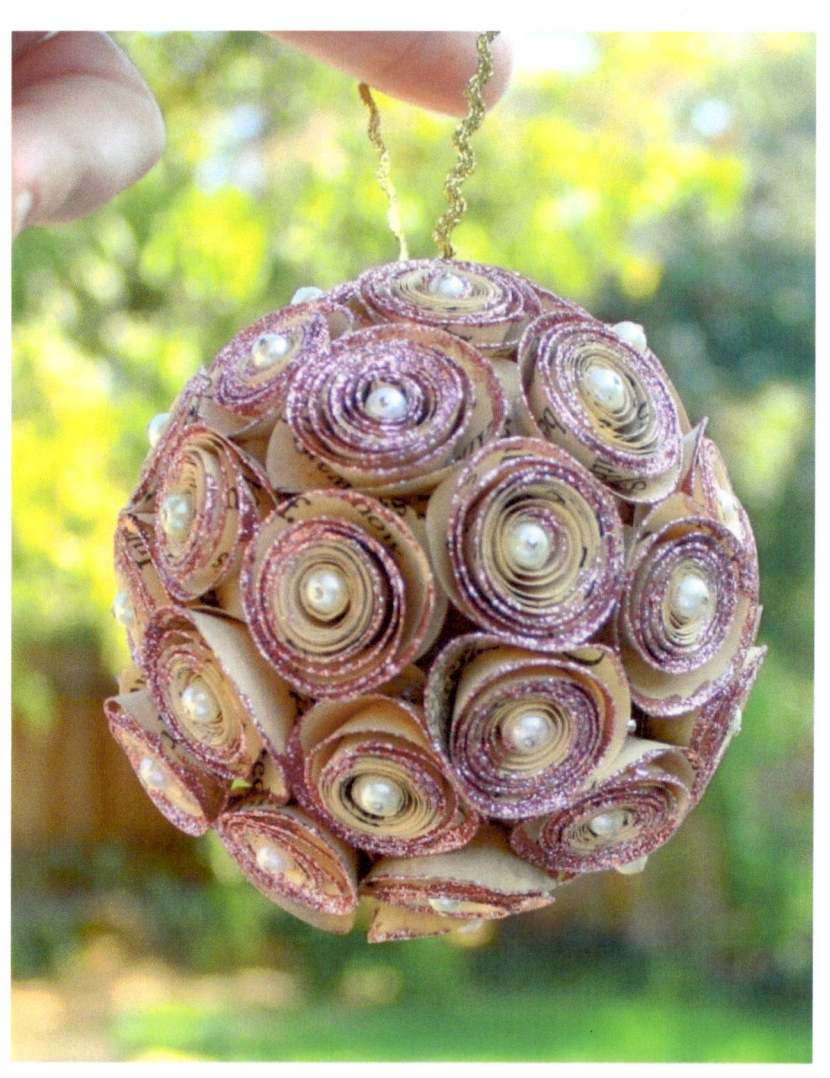

Little Pink

One night as I lay dozing,
Upon my window came a tap,
And looking out with bleary eyes,
Found a sight to end my nap.

There floating in my backyard,
Six feet off the ground,
Was a ball made of pink roses,
From it came a humming sound.

As I gazed upon the thing,
Opened a tiny little door,
Out stepped the smallest woman,
Three inches of sass and allure.

"My name is Little Pink", she said,
"And I've come to conquer you.
Give-up now 'cause your women will,
Love me far more than you."

I contemplated what she said,
And was about to give in,
But the cat jumped off the roof,
And ate her. That's how we came to win.

10/21/15

Commentary p.65

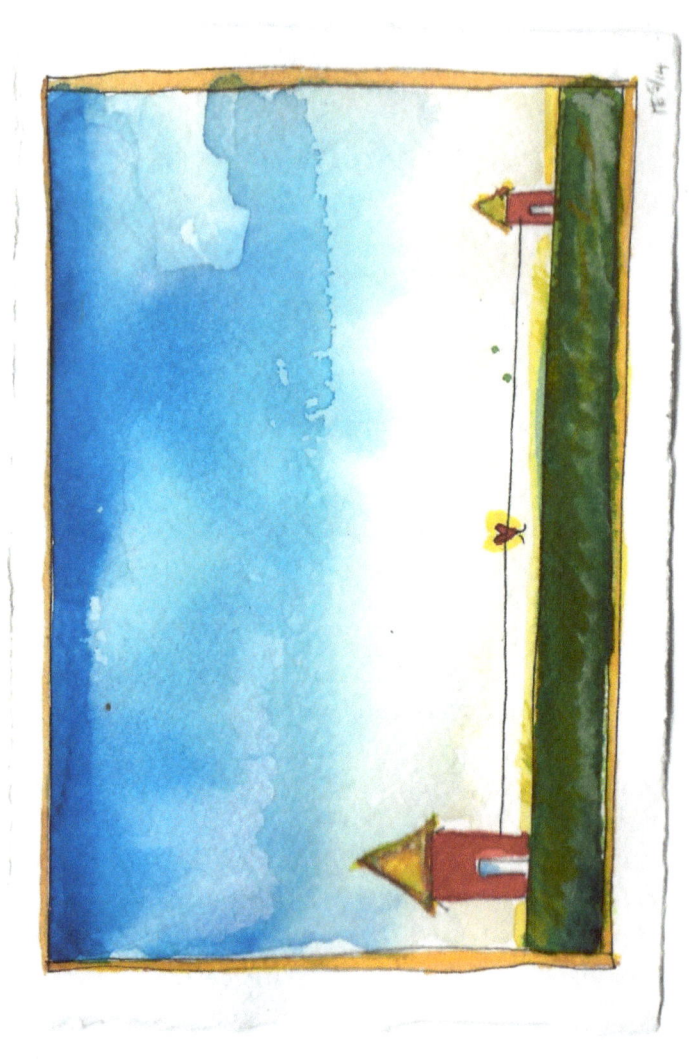

The Little Red House: My Child

For so many years I've waited,
Slowly the days have passed,
He's what I anticipated,
The joy has come at last.

Place him in my loving arms,
I'll hold him tight and fast,
The emptiness inside is gone,
The joy has come at last.

And my dear man who gave him,
In a new light is cast,
Despite the foibles, he's a bit dim,
The joy has come at last.

As the child grows older,
Together we'll have a blast,
We needed this hug-holder,
The joy has come at last.

10/21/15

Commentary p.66

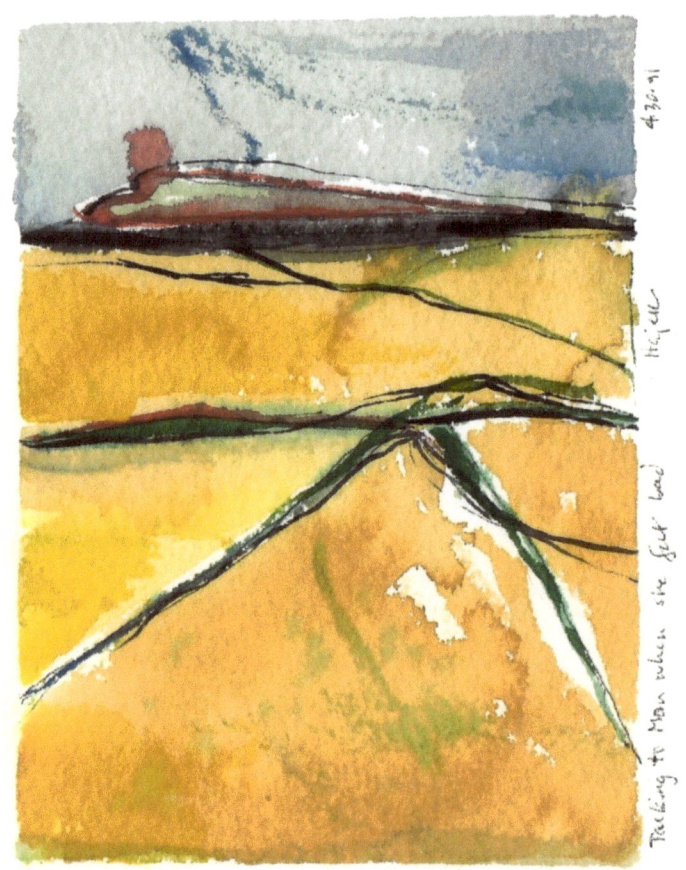

In Her Silence Was a Cry

In her silence was a cry,
Haunting solitude in her eye,
When I gently asked her why,
"It's nothing, really", came the lie.

I was bright with cheerful care,
Perceiving melancholy there,
Kissed her cheek and stroked her hair,
Understood her cross to bear.

As though her heart were icy-clad,
Then touched by warming sunlight glad,
Her smile broke forth, no longer sad,
Talking to my mom, when she felt bad.

9/25/15

Commentary p.67

A woman, a spaniel, a walnut tree

∴ THE MORE YOU BEAT THEM
 THE BETTER THEY BE... ∴

A Woman, a Spaniel and a Walnut Tree

A woman who's lovely, proud as can be,
Responds with great vigor, best her, you'll see.

A spaniel needs training, regularly,
Run him and hunt him, a schedule you'll need.

A walnut tree's special, gives so freely,
Careful when nutting, not too severely.

A woman, a spaniel, a walnut tree,
The more you beat them, the better they be.

10/21/15

Commentary p.68

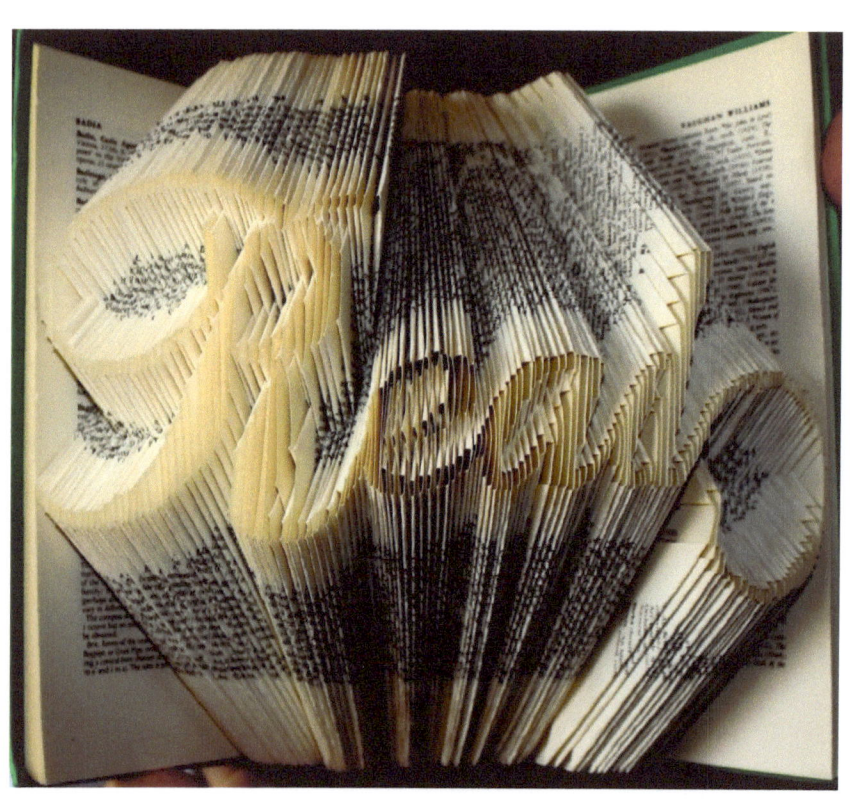

Read

Such a simple word,
For an amazing task,
To read, to cypher,
Tis a grand thing you ask.

Strokes upon a page,
Symbols of vast meaning,
Recognize a shape,
Understanding gleaning.

How can "I" mean me?
Three lines that mean myself?
Magic mysteries,
In books up on the shelf.

Yet you have learned this art,
To bring thought from mere lines,
Raises man above,
From beastly to divine.

10/23/15

Commentary p.69

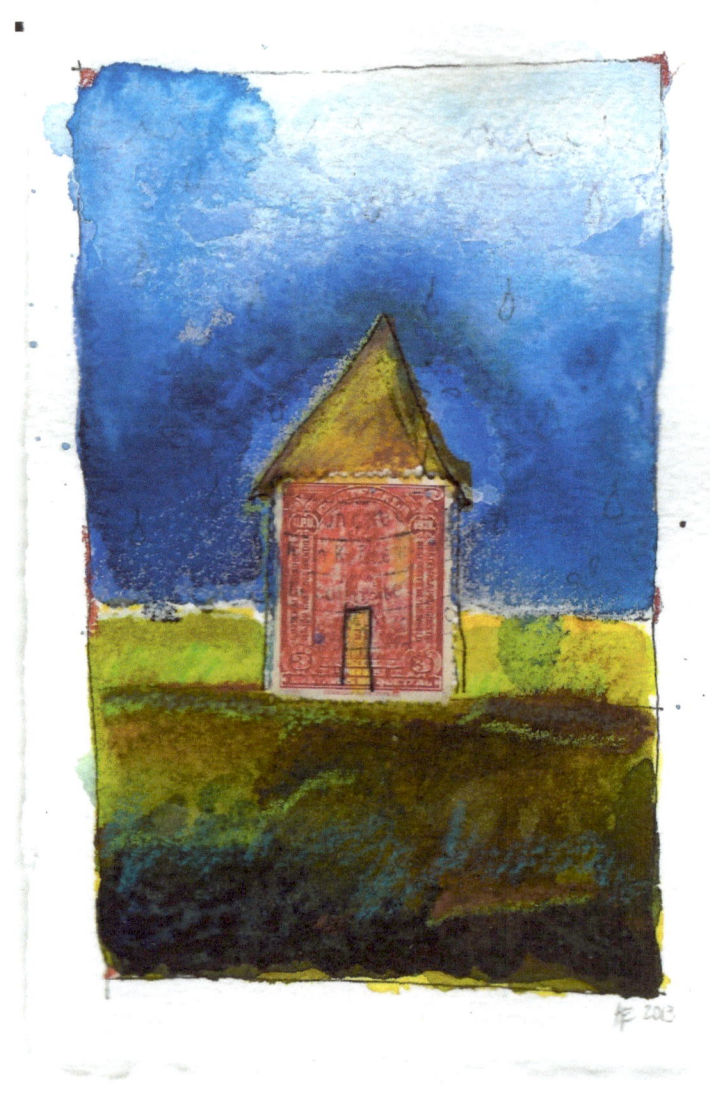

The Little Red House: Settling In

The joists may be creaking
The roof sprung a leak or two,
Windows cracked, new paint lack,
Need surgery on the flue.

My foundation slightly crumbled,
Walls bow out a tad,
Back door sticks, tile nicked,
But in all it's not so bad.

I have a family who cares for me,
Accepts me for what I am,
All the flaws and odd guffaws,
They give a tinker's damn.

So long as joy's within the house,
Then life will be so sweet,
No more alone, I'm loved, I'm home,
I'm finally complete.

10/24/15

Commentary p.70

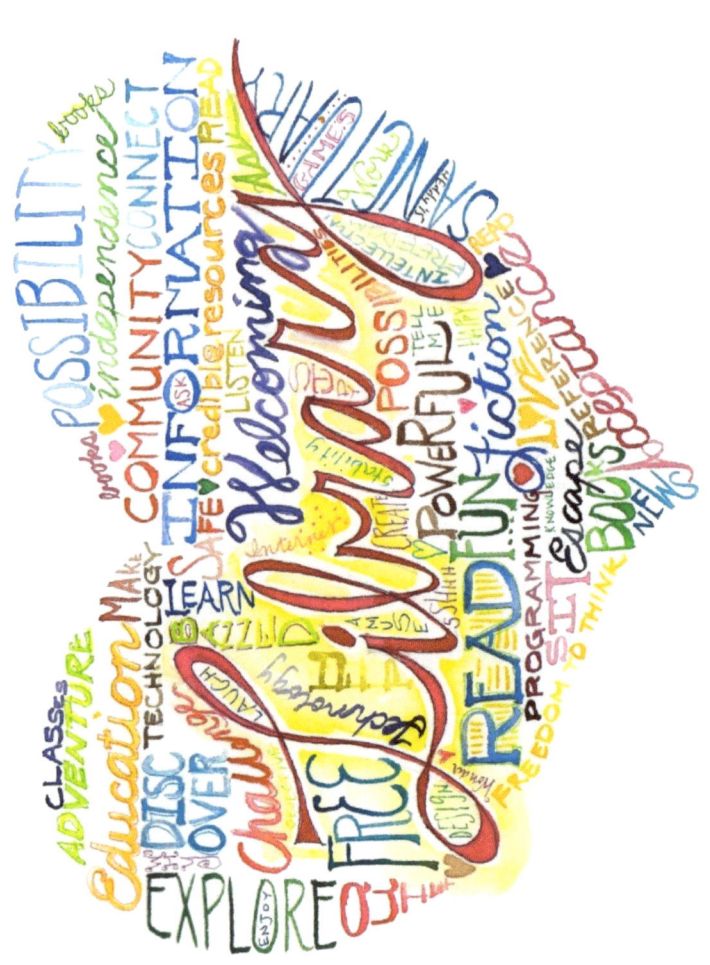

Lovebrary

The library is a joy,
So much more than just mere books,
If you think its dusty shelves,
You should take another look.

Children's Corner is a place,
Where dreams can come alive,
Wonder is a daily gift,
Each morning at story time.

For you techies there's a room,
Full of movies and CDs,
Things you won't find on Netflix,
Or in your online streaming.

Ever have a question 'bout,
Most anything in the world?
Reference can give you answers,
And help your mind to unfurl.

The library is a joy,
Puts community above,
Though yes, it is their living,
It's done mostly out of love.

10/23/15

Commentary p.71

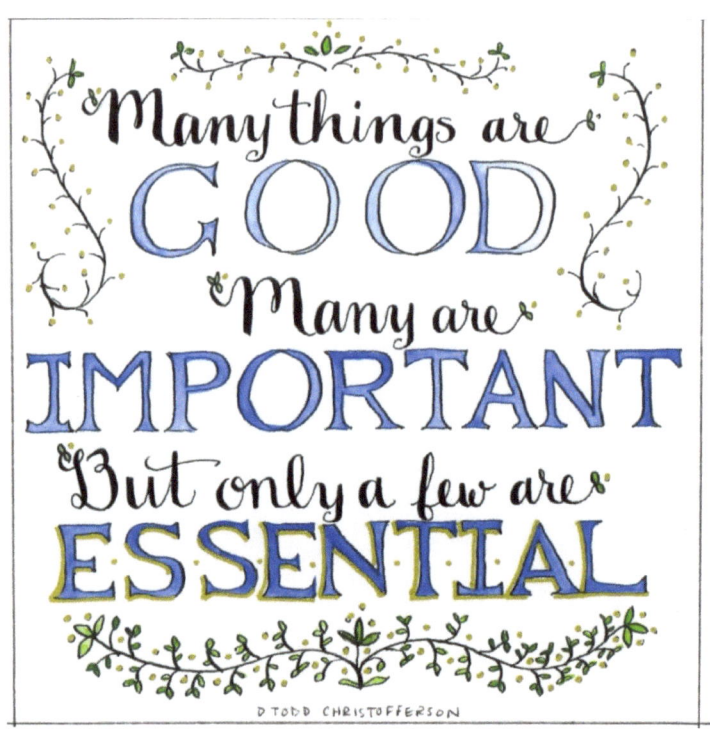

When the Time Comes

MANY THINGS ARE GOOD…

A hundred things to ponder,
A thousand things to do,
I want to have them all but,
Time forces me to choose.

MANT THINGS ARE IMPORTANT…

I must fulfill my duties,
Build relationships with friends,
Care for those who need me,
Will this service ever end?

BUT ONLY A FEW ARE ESSENTIAL

Have I served my Lord on high?
Am I a righteous man?
Do my wife and children know?
The gospel and His plan?

10/18/15

Commentary p.72

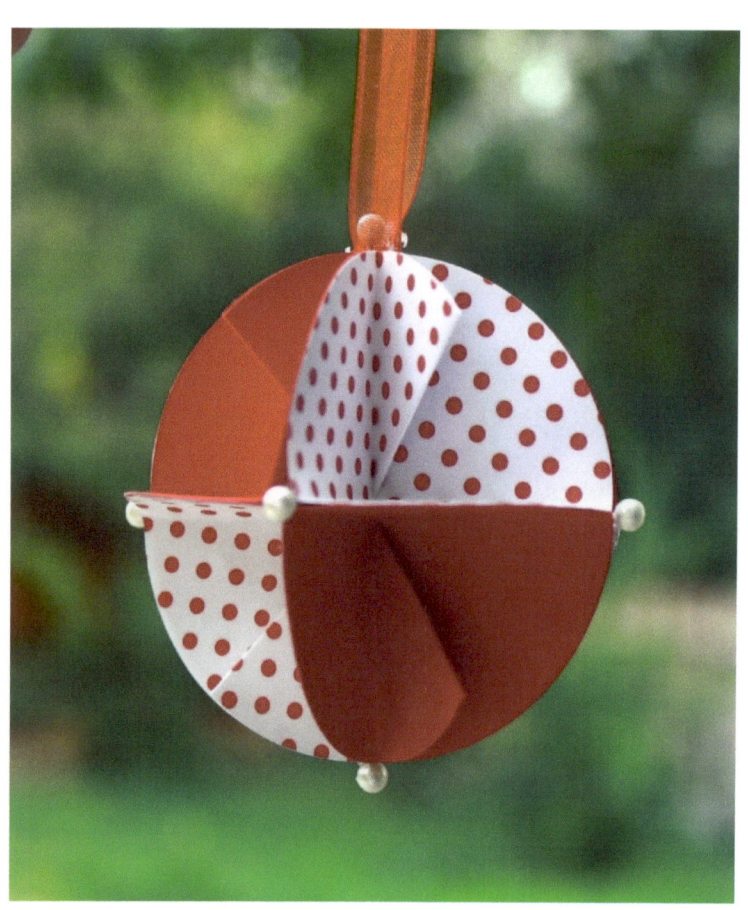

The Polka Dot Ball

I went to my grandma's,
For a Christmas feast,
And saw she had an ornament,
A polka-dotted beast.

I asked her, "Hey Grammy,
Where'd ya get his thing?"
She leaned in close and whispered,
"It's the story of a ring"

"Your Grandpa was a hep cat,
With a classy chassis too,
We cut out for the evening,
To the passion pit revue.

When an actor and an oddball,
Tried to razz my berries,
He said, 'Ya cruisin' for a bruisin''
Pounded them, they piled up the Z's.

Then we punched it off to lover's lane,
We were so much more than tight,
Jeepers we were cookin'
He circled me that night."

I looked at her with a grin,
Asked, "Grammy, you alright?"
It fractured me to realize,
My Gran was outta sight.

10/23/15

Commentary p.73

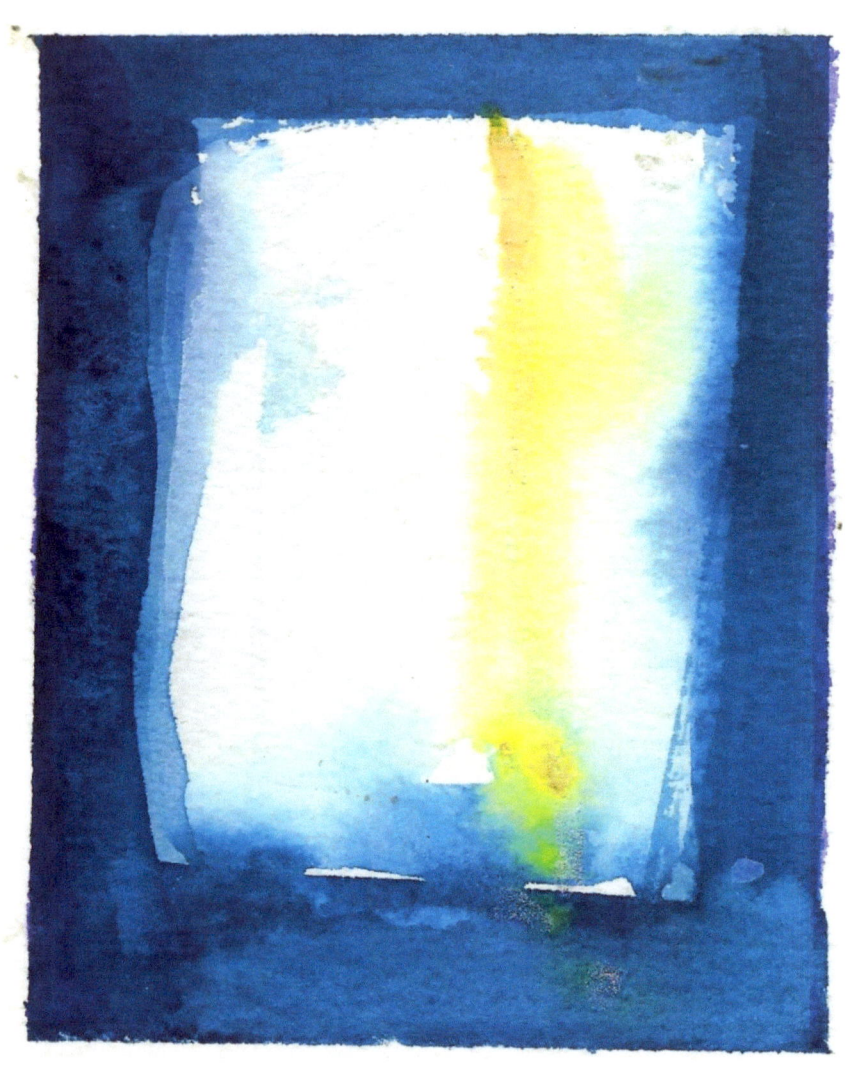

Mortality's Fall

Mortality's Fall

A door, bursting, glory streams

Sweet eternity

9/2015

Commentary p.74

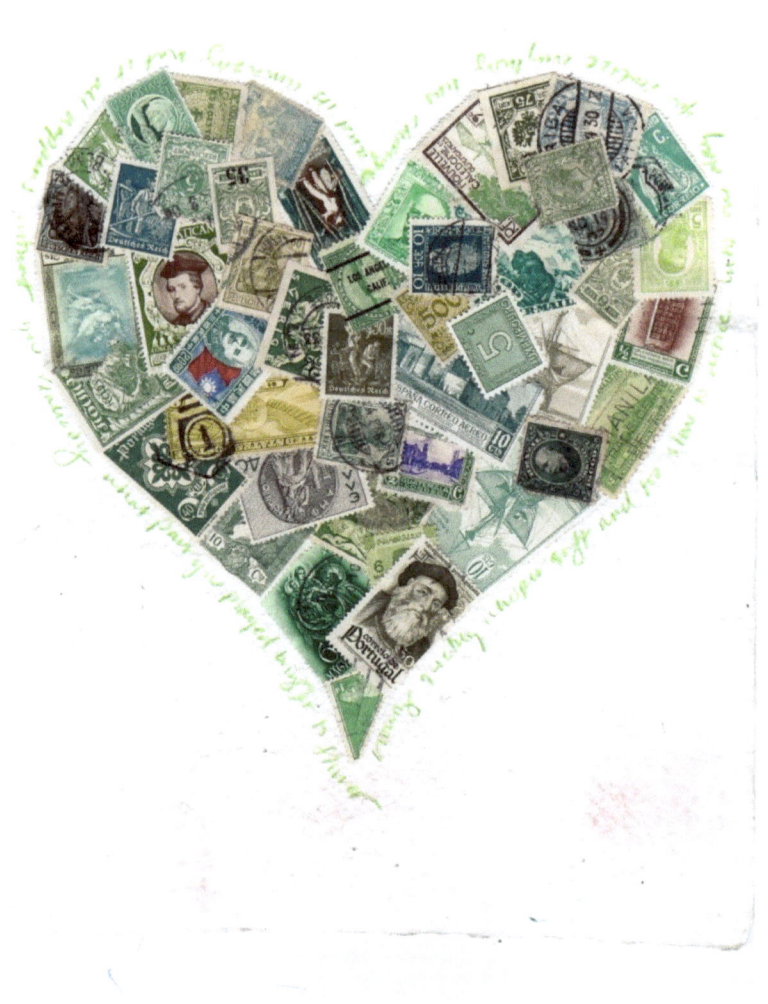

A Green Heart

This lonely ball of blue and green,
Floating gracefully through the void,
Is the home of you and me,
Our wisdom should be employed.

We're not just freaks of nature,
But custodians of this sphere,
It was made to fulfill our needs,
We were made to treat it dear.

All the treasures of the earth,
Great and vast resources,
Provided to support us through,
Our divinely inspired choices.

But what evil monster,
Defiles its own lair?
No blood-thirsty creature vile,
Takes and takes with no care.

So let us use the gifts,
Which God has set before,
Yet be loving stewards,
Don't destroy, that's Satan's chore.

10/24/15

Commentary p.75

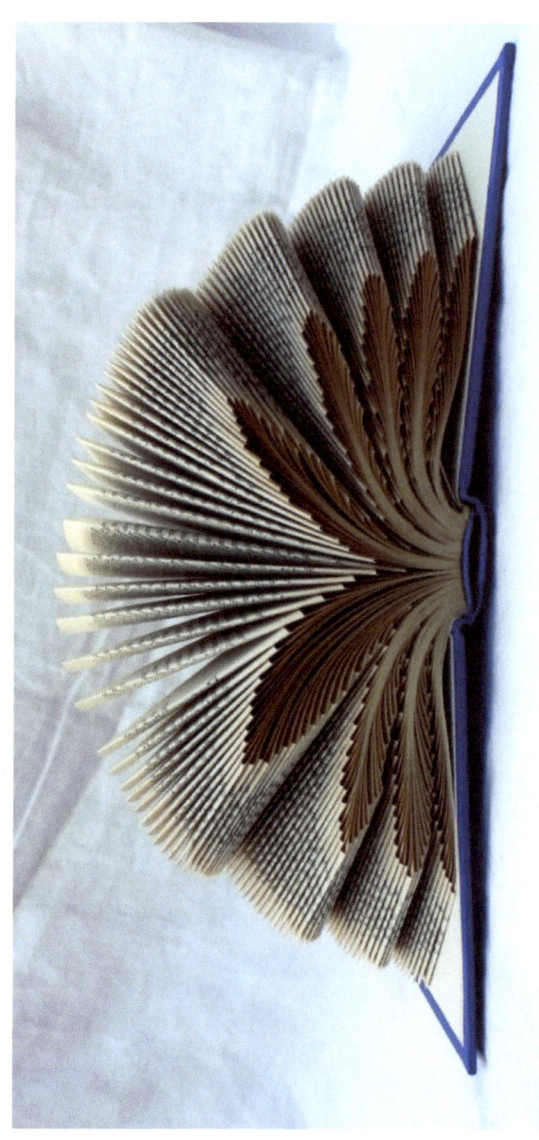

Wheat Sheaves

Gather in the sheaves,
Find the grain that's whole,
Fill the Master's barns,
With pure and precious souls.

Gather in the sheaves,
The bent and broken ones,
Bring them to the threshing floor,
Sift them one from one.

Gather in the sheaves,
Those bruised and trampled down,
Perhaps within the myriad lost,
Some worthy can be found.

Gather in the sheaves,
The fire's burning bright,
Burn down the field, stalk and chaff,
Then comes the final night.

10/24/15

Commentary p.76

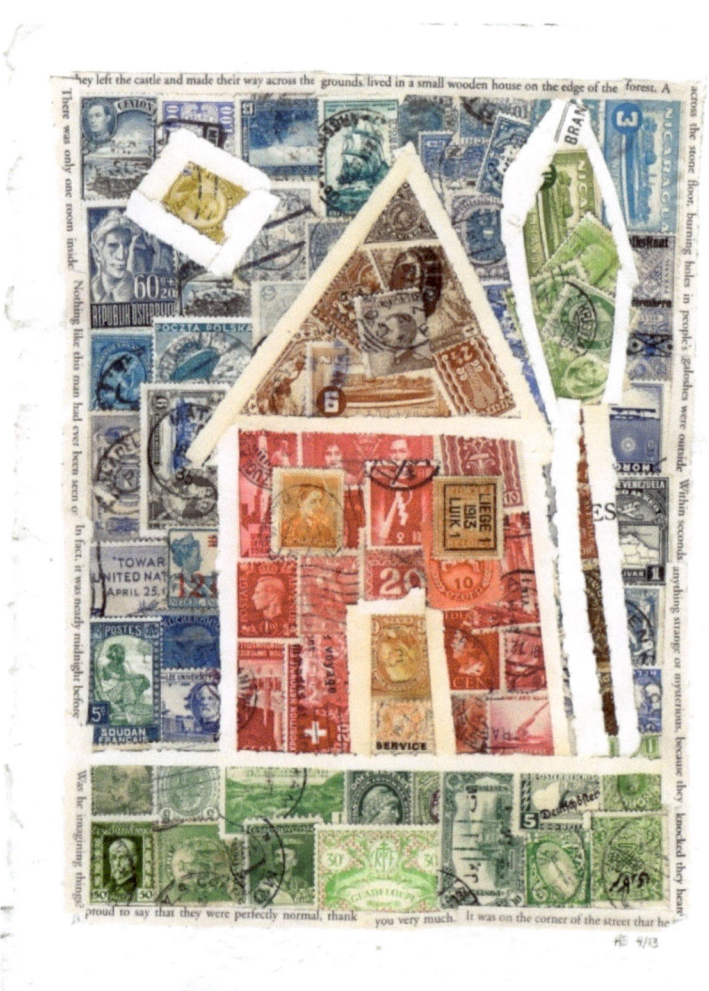

The Little Red House: In Repose

I've survived the lonely times,
Didn't know who I was,
And I've seen the stormy days,
Knocked down by freezing gusts.

Passed through the weakness and endured,
Betrayal of the heart,
Found my feet and bore up strong,
Another brand new start.

Came the love I waited for,
Not perfect but who is?
And a child of my own,
To fill the void within.

Now as day begins to fade,
My work is all but done,
I can say with confidence,
I've run the race, and won.

10/24/15

Commentary p.77

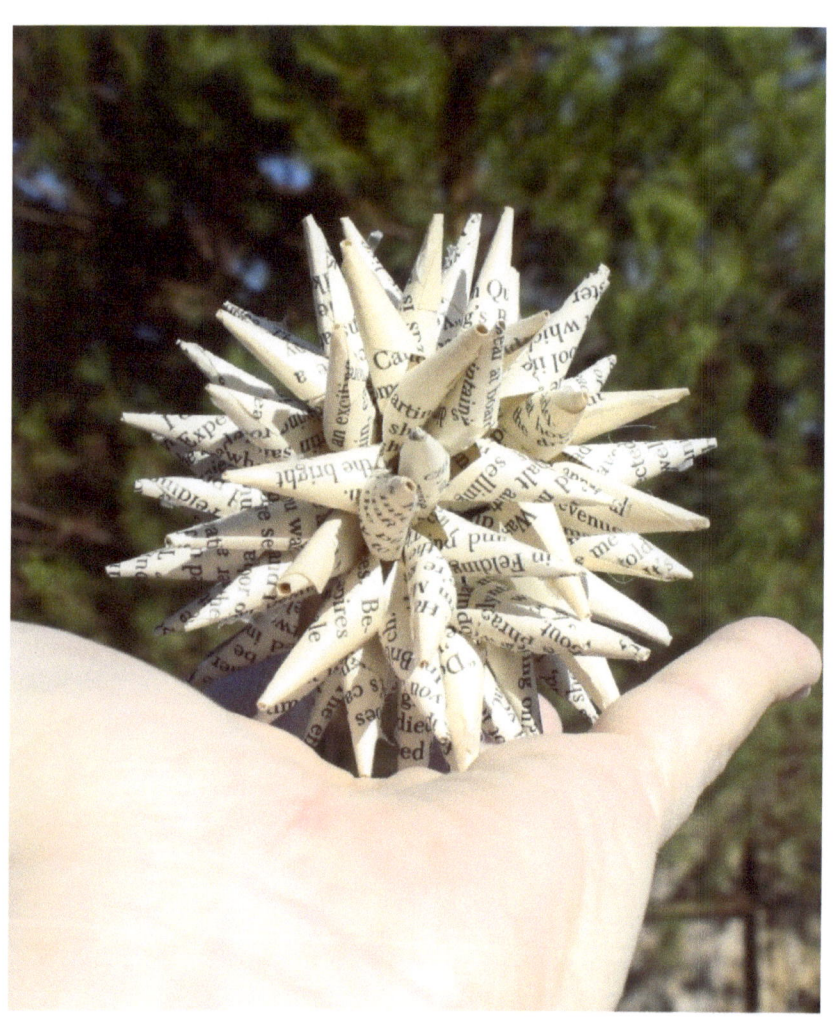

When the Spikes Come Out

Most days I'm just a gentle,
Smooth, inviting ball,
Ready for a cuddle,
You simply have to call.

I mostly have a smile,
To share with all I see,
Be a friend and watch,
How wonderful I can be.

On the other hand…

If you treat me like a fool,
Lie, or break my trust,
There are endless ways I can,
Grind you into dust.

If you get on my bad side,
Then you should never doubt,
The entire universe can't save you,
When the spikes come out.

10/24/15

Commentary p.78

Rosemary green
lavender blue
thyme & sweet marjoram
hyssop & rue

Rosemary

Rosemary green, a delicate thing,
My love found a spriggle or two,
She gathered it up to spice-up her sup,
And the air in our cottage renew.
A hey-ho diddley-ain
She's walking in gentle spring rain.

She danced a fine reel way out in the fields,
And picked her some lavender blue,
She wanted to dye her new bonnet with pride,
And maybe a stocking or two.
A hey-ho diddley-aye
She's singing in summer sunshine.

Herbs she would need, and fresh berry seeds,
To make us some jellies and jams,
Haste she did make, lest burn'ed the cake,
Finding thyme and sweet marjoram.
A hey-ho diddley-all
She laughed at the first days of fall.

No more could she run or dance in the sun,
For the days were all cloudy and gloom,
But cuddle with me by the fire with glee,
Mid aromas of hyssop and rue.
A hey-ho diddley-ime
Warm love in the cold wintertime.

10/19/15

Commentary p.79

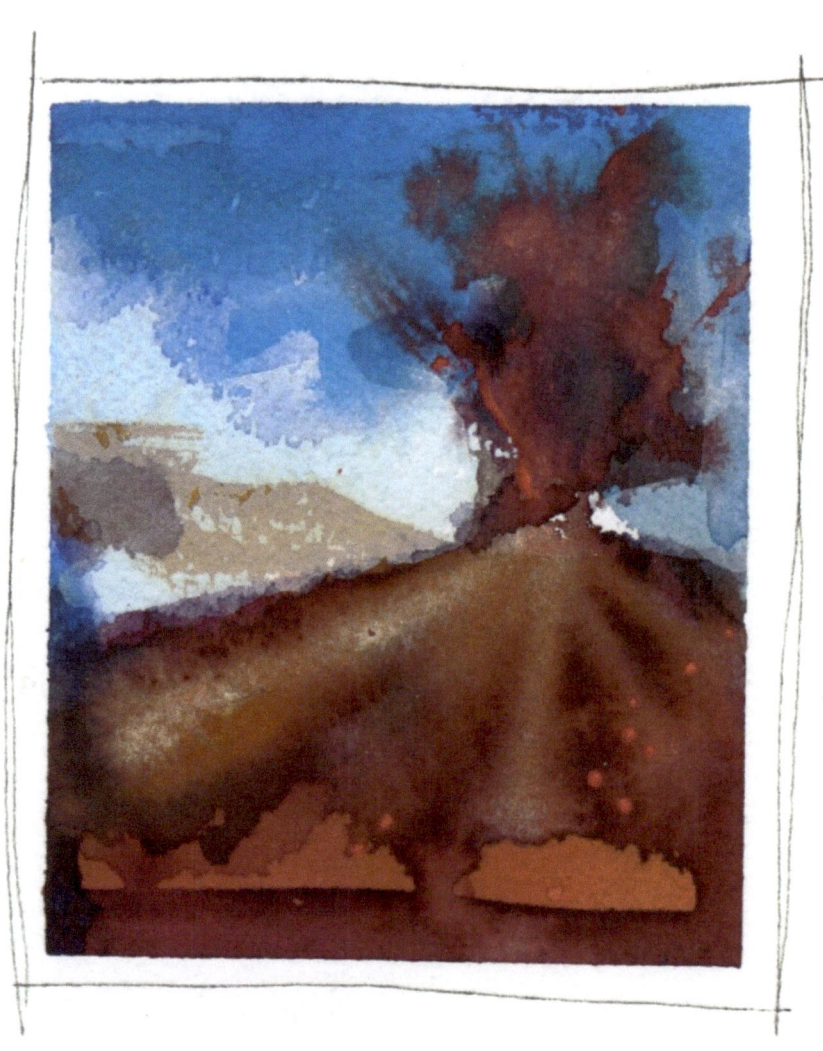

Volcano

Deep within the molten core,
Where everything's in flux,
Elements flow undefined,
Connections are pure luck.

Slow at first, the pressure builds,
Rising toward the top,
Blockages are overcome,
A burst that cannot stop.

All about the countryside,
Change comes raining down,
Wherever the idea falls,
To think, their minds are bound.

I have almost no control,
When the art will erupt,
The flow may be unpleasant,
It's worse to interrupt.

10/25/15

Commentary p.80

Commentary

A Baby Star p2 (p)

As you may have noticed, there are a lot of star themed pieces in these books. I wanted to do this one particularly because it is so unique among the crowd. Initially I was inspired to talk about two stars joining together but it didn't go anywhere. Eventually its tiny delicate nature carried the day.

Come Unto the Ark p8 (w)

Poetry is an expression of what I am feeling inside. This was written while at a funeral for a dear lady (see: *She Sang the Song of Love* p10). The obvious connection between today and Noah's time cannot be overlooked.

She Sang the Song of Love p10 (b)

Growing-up there was a sweet girl with whom I went to church and school. We were never close friends and ran in completely different circles. She was a very popular cheerleader and I was lucky if my teachers knew my name. Decades later the girl's mom was again in my church congregation and we, mom and I, struck-up a friendship. When I heard she was in the hospital I went to see her and let my old acquaintance know. Just under two weeks later mom passed away. I wrote this simply as a way of comforting Jennifer. She liked it so much that I was asked to read it at Sandy's funeral. The book is my interpretation of how Sandy used to lead the music as chorister.

Paper Roses p12 (p)

Also written in the pews before Sandy Tardiff's funeral (see Commentary pp 57-58) Paper Roses expresses the love Heather puts into her artwork. There are endless ways of symbolizing such things and I hope this one is okay.

The Little Red House: Something Here Inside p14 (w)

People looking to fill a void within themselves often have no idea what it is they seek. They will try various things, from career to love to drink. Sometimes they know exactly what it is they want but have no means of getting it.

Crevasse p16 (w)

Brian feels very comfortable with tradition. Knowing what to expect from each day feels very safe. Occasionally that means falling into a rut which only grows deeper with the passage of time. *Crevasse* reminds me that we are meant to act and not be acted upon.

Poppy p18 (c)

The red poppy is a solemn token of the lives lost in WWI. Unfortunately, I forgot that the color was important. I was almost finished when I suddenly realized that Heather's poppy, while lovely in itself, was primarily yellow. Hence, I had to change the mood and direction of my work by offering the yellow poppy as a symbol of healing rather than just remembrance.

Relief Always Comes p20 (w)

Life as a dry desert is another recurring idea throughout these books. I was born and raised in Bakersfield which experiences long hot dry summers sometimes lasting 8 months and routinely topping 100 degrees.

This image evoked that parched feeling as soon as I looked at it the first time. Indeed, my mouth literally went dry.

Crazy In Love p22 (w)

Much like an abstract painting, when Heather presented me with calligraphy of *Well, what did you expect?* my first thought was, "What do <u>you</u> expect?" There are only two ways one can proceed: either full-on rebellion and sarcasm or complete absurdity. Luckily I was in a silly mood at the time

Little Pink p24 (p)

As a child, my parents purchased me a set of early reader books called *Read about Me and the Bee*. Some basic information about the child would be sent in and entered into the text to make it seem the child was a featured character. Yes, I loved it and read them obsessively. My absolute favorite was about a spaceman we called "Little Pink" who took me to a series of planets where anything was possible.

This folded paper ball reminded me of what I expected Little Pink's ship to look like.

The Little Red House: My Child p26 (w)

For people immersed in a sense of family, having that first child is not just an achievement or milestone but a moment of pure elation. Heather waited so long, I was proud to have been part of her joy.

In Her Silence Was a Cry p28 (w)

This is one of the very few pieces where Heather gave me an indication of what she was thinking. I wanted to capture the raw emotion that would have been present when an adult child tries to comfort their parent.

A Woman, a Spaniel and a Walnut Tree p30 (w)

It is a truism that one cannot judge the past by today's standards. What was perfectly acceptable behavior then would shock us today. Heather and I were suitably nonplussed when she read a couplet to me from an old book of wise sayings. I used those lines as the final phrase in this poem.

My challenge was in how to bring the words forward into acceptable modern sensibilities. Obviously I had to make use of all the meanings to the word "beat" and even then I am not sure it worked perfectly.

Read p32 (p)

The concept of reading is really quite amazing. In English we use just 26 symbols to represent every word imaginable. Another fifty or so give us punctuation or specificity. Yet through these scratches we can convey ideas of the most abstract form. Anthropology tells us that the written word is the only way to preserve thought through time and space. Pictures are open to interpretation. Audio can be misunderstood. But words, words have meaning within their own time and extend throughout time. They are infinitely portable. If I bury a copy of the U.S. Constitution in the sand today and it is found in 10,000 years, it will still make the same demands on humanity as it did when written. It is writing that creates a sustainable society.

The Little Red House: Settling In p34 (w)

Of all the *Little Red House* poems, this one represents Heather today. She has been educated, found a suitable mate, had a child, and is becoming comfortable in he own skin. This should be the time of her greatest contentment.

Lovebrary p36 (c)

Heather works for the County Library system. Much like an athlete who winds-up behind the microphone, the library wasn't her first choice but rather a chance to be around things she loves…books. I am certain that she would rather work as an archivist at some international repository of rare and antique manuscripts.

The poem and image are meant to support the library in a time of public policy chaos.

When the Time Comes p38 (w)

The quote is from a General Authority in the Church of Jesus Christ of Latter-day Saints. His desire is to help us recognize that in the vast array of competing interests, many are good, valuable and important, but only a few are essential to our salvation. By all means, have joy in this life, but not at the expense of Eternity.

The Polka Dot Ball p40 (p)

This ornament immediately reminded me of the 1950's. That, of course, led me to my grandparents. On the occasion I try to write something humorous, misdirection or incongruity are my preferred tools. What then would be funnier than Grandma telling a story about how she and Grandpa got engaged in the slang of the time? Not only would we not understand but probably take some of it as quite naughty.

hep cat: cool or with-it guy
classy chassis: nice body
cut out: left
passion pit: drive-in theater
actor: show-off
oddball: unsocial, geek or nerd
razz my berries: impress a girl
cruisin' for a bruising: stirring up trouble
piled up the Z's: slept or got knocked out
punched it: left quickly
tight: close friends
cookin': doing something well or correctly
circled: put a ring on, proposed
fractured: confused or surprised
outta sight: great or cool

Mortality's Fall p42 (w)

Poetry is perhaps the least controlled form of literature. There are endless ways of composing a poem from Shakespeare's sonnets with set lines, rhythms and meters to the completely freeform stylings of Maya Angelou today.

I never wanted to be constricted to any one manner of writing and will, when aware that my stuff has become too routine, shake things up a bit. Thus it was time for a Haiku.

The ancient Japanese poetic form (as I understand it) is made of three lines in a 5-7-5 meter. Many writers today only follow that rule. However, traditional Haiku have two more important rules: 1) a reference to the seasons and 2) in the second line should be a transition word upon which the first part of the poem pivots into the second. In other words, to be a true Haiku, the poem must tell the story of change from one thing to another and draw essence from the seasonal background.

Mine refers to the autumn of life and that moment when the mortal becomes immortal.

A Green Heart p44 (w)

Environmentalism, as the agenda stands today, has very little to do with protecting the planet and the living creatures upon it. That would be Conservation. The Green Movement is about politics, power and money. Don't let anyone tell you differently.

My Faith teaches that we are custodians of this earth, given to us to provide the necessities for Mankind. We are promised that there is enough of all the natural resources IF we are wise in our use thereof.

The current scares about "using up" nature are based on the idea that this world will last another 10 million years or more. Christianity does not adhere to that idea.

Wheat Sheaves p46 (b)

Whenever possible I tried to keep the imagery and titles which Heather gave to her art. She named this book and so naturally the poem would follow suit.

The biblical teachings about the wheat and the tares (Matt 13:24-30; Luke 3:17) would be the logical theme.

The Little Red House: In Repose p48 (w)

Looking ahead to that time when the work is done and in our old age we rest, preparing only to meet our maker and receive our just reward.

When the Spikes Come Out p50 (p)

Everyone can be a little prickly sometimes and this is not meant to be any particular individual speaking. On the other hand, I do have a bit of a temper which I keep tightly controlled. This could be me, though I don't want it to be.

Rosemary p52 (w)

Another of the wise sayings Heather found in her book. It felt very rural and old to me, like we were peeking into someone's life from the 1600's.

My conceit is of it as a song. Four male leads would each take a verse and the chorus would sing the couplet.

The Volcano p54 (w)

Any internal struggle can be viewed as a volcano. Certainly anger, ambition or sexuality would work. I chose to use it as a simile of creativity itself. I tend to write in obsessive bunches. It may last a week or a month and then nothing for many moons. When then mood does strike it is nearly impossible to constrain.

About the Authors

Heather

Heather (Hajek) Eddy was born and grew up (mostly) in California; earned a BFA in watercolor and printmaking from Brigham Young University; and a Masters in Library Sciences from San Jose State.

Her art is an eclectic mix of watercolors, folded paper and anything which elevates the soul.

Original works and prints are available at Etsy and Society6

Brian

Brian Eddy is a semi-pro author whose books, *Psalms of My Life v 1-3, Mingos and Sharp Parts,* and *My Sister the Zombie* are available at online retailers.

He dabbled in Kung Fu San Soo for a number of years, earning an 8th degree Black Belt.

Brian likes to do things he's not good at like singing, dancing and being funny. Luckily he has close friends who mock incessantly to keep him in his place.

www.ingramcontent.com/pod-product-compliance
Lightning Source LLC
Chambersburg PA
CBHW041103180526
45172CB00001B/81